I BELIEVE IN SEEDS
AFFIRMATIONS FOR REWILD

PAINTINGS BY
EMILY LUPITA

POEMS BY
JOSEPH S. PLUM

PUBLISHED BY ARTIST EMILY LUPITA
IN COLLABORATION WITH DREAMING DEER PRESS
LOVILIA, IOWA, USA

ISBN-13: 9798458479196

ARTIST PHOTOGRAPHS BY EMILY LUPITA

PRINTED IN THE UNITED STATES OF AMERICA

WWW.EMILYLUPITA.COM

WWW.JOEPLUM.COM

THIS BOOK WAS MADE POSSIBLE BY A COMMUNITY ART GATHERING GRANT
FROM THE BEWILDREWILD FUND AT IOWA NATURAL HERITAGE FOUNDATION.

WWW.BEWILDREWILD.ORG

ARTIST

EMILY LUPITA

BeWild
ReWild

Dreaming Deer Press

gratefully, forever and again,
for the wolf who is a friend,
for the hawk who becomes a man,
for the bee who dances at this world's end,
and for the great stag of the red speech
of the ancient tongues of the wind,
i dedicate this division of dark and light
to every unknown, to every known
who has ever slipped from being
into becoming, that i might begin
coming into being, forever and again.

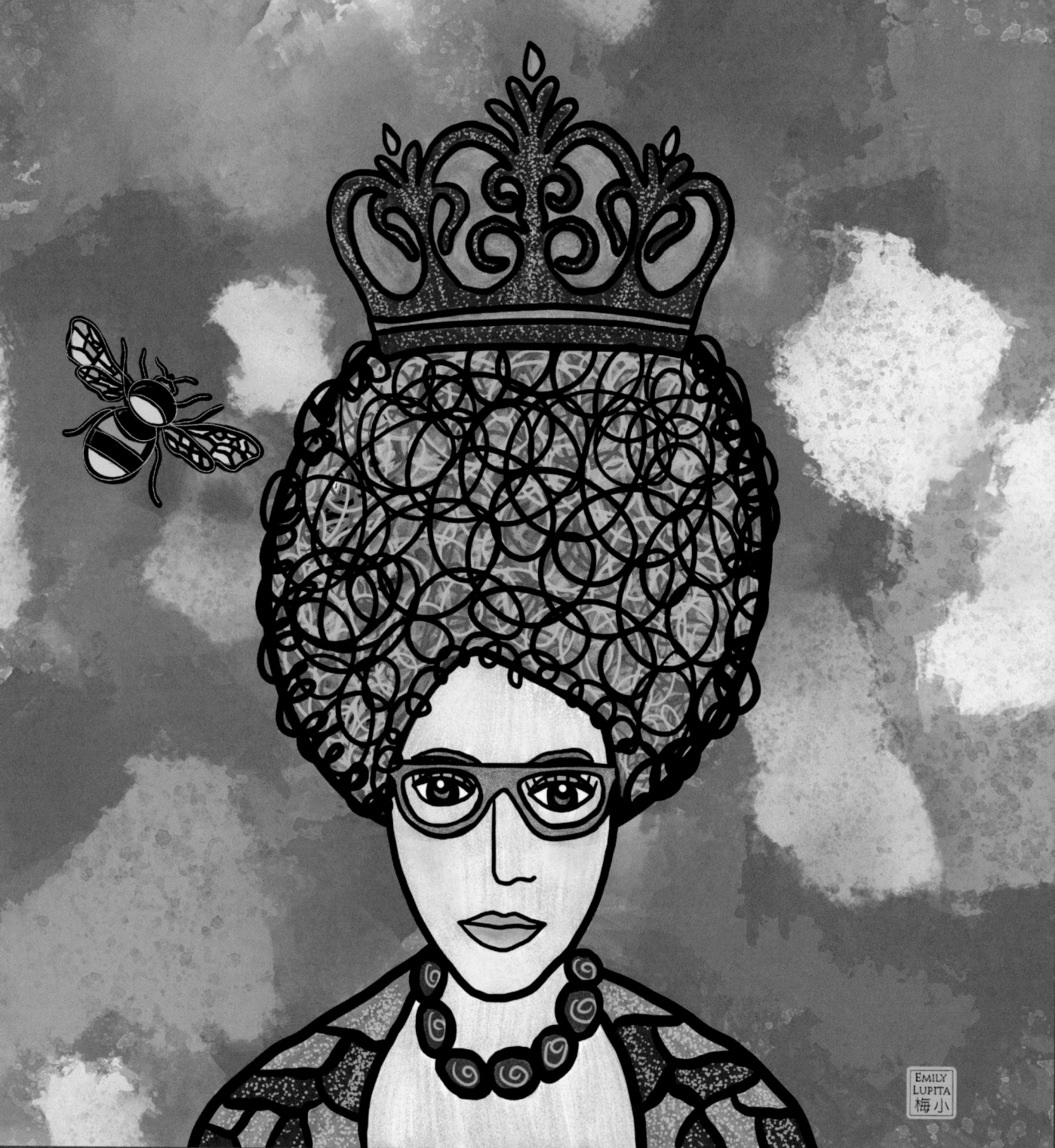

i believe in seeds
planted in wild places,
in the taste of river mist
and the smell of sages.

i believe in mountains
while crossing the borderline
and bridges in the desert
spanning the depths of time.

i believe in sunlight
filtering through green leaves
and in shadows of untold winters
hugging the branches of trees.

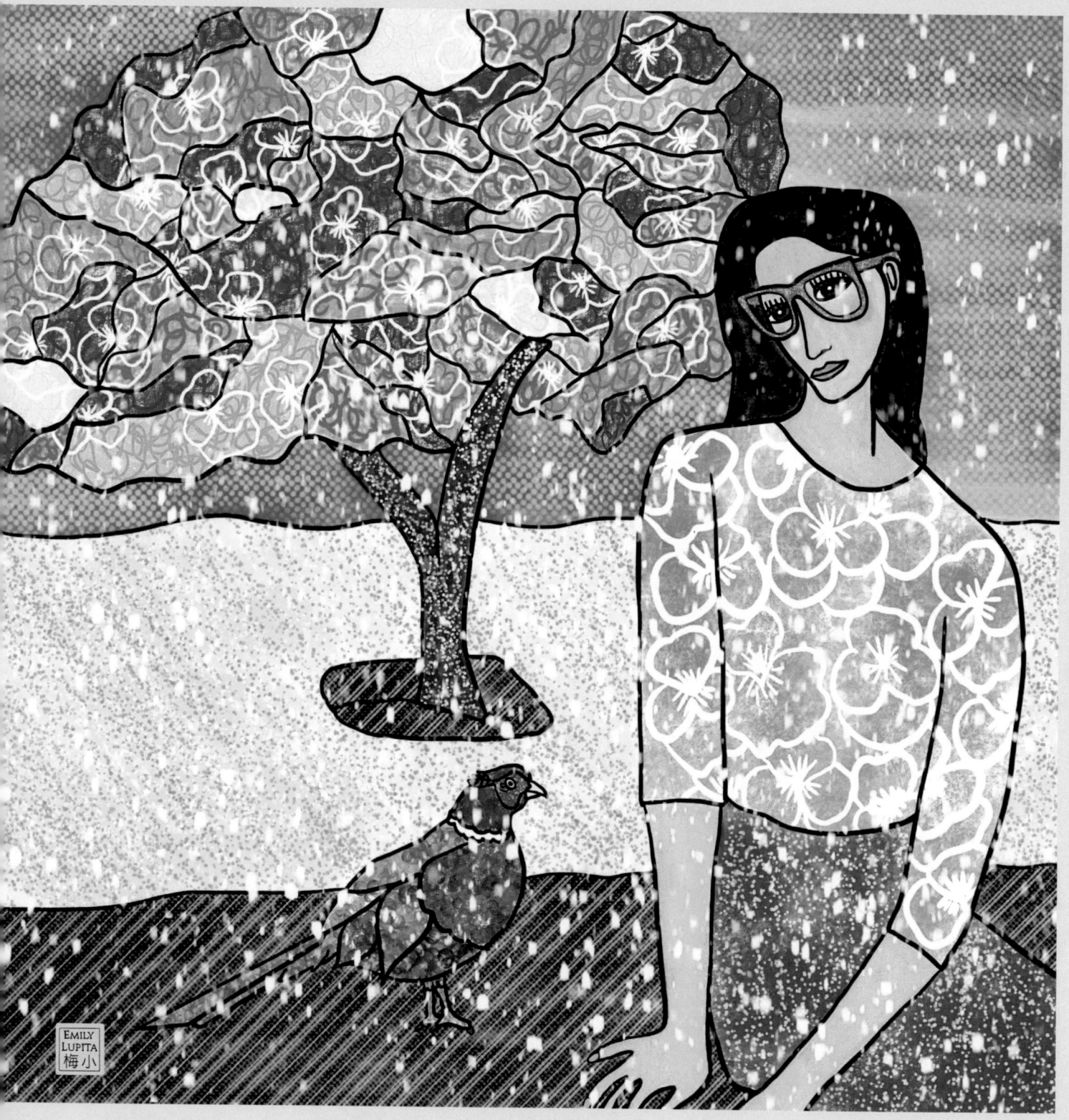

THERE MUST BE WILD WISDOM IN MY LIVING,
A PATHWAY OF MEMORY SKILLFULLY OUTLINED,
ENDURING WORDS OF DEEP UNDERSTANDING
FLESHED OUT IN FEELINGS – SWEET AND SUBLIME,
A PULSATING LANGUAGE OF VERTICAL WISDOM
UNFOLDING WITH THE GREATEST TREASURE
A SEEKER CAN FIND:
AN ANCIENT METHOD OF PRESERVING IN ESSENCE
A MESSAGE THAT REASON NEVER DEFINES,
THE SECRET – A MYSTERY OF UNBOUNDED BEING
CONTENT NOW FOR THE MOMENT
TO REMAIN PARTIALLY HIDDEN
BY THESE QUIET SPACES BETWEEN THE LINES.
YES, THERE MUST BE WILD WISDOM IN MY LIVING.

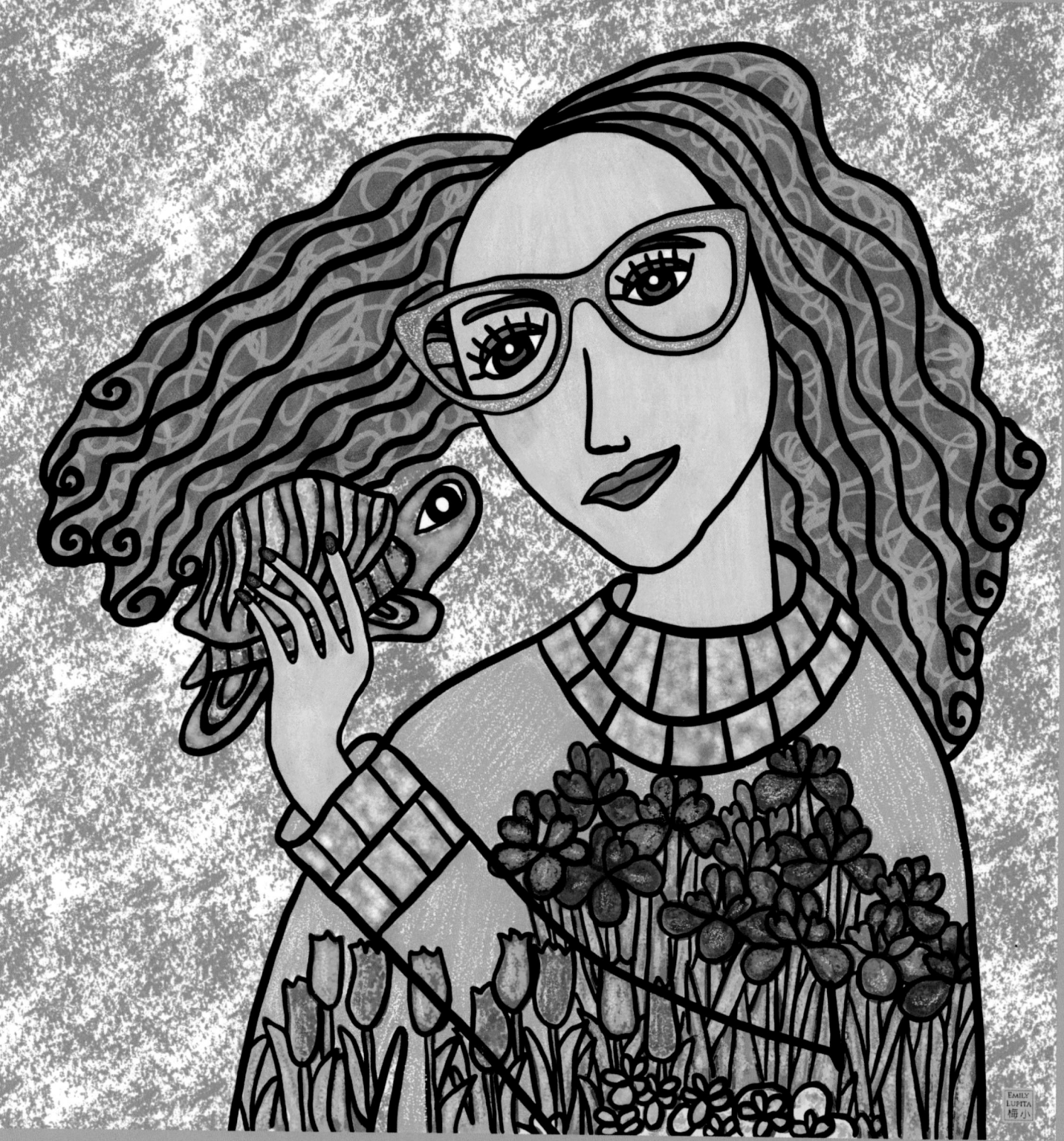

the sun has traveled well
since the last time that we met

and these hills have dreamt
a thousand journeys, peopled
with one hundred promises kept

and all the while a shadow from this land
across the moon's bright face has crept
and all the while the trees are bent with wonder
at the weight of the leaves they've wept

and now the sky can keep no longer
thunder beating in its chest
and now the wind wishes only to surrender
each and every precious breath

yes the sun has traveled well
since the last time that we met

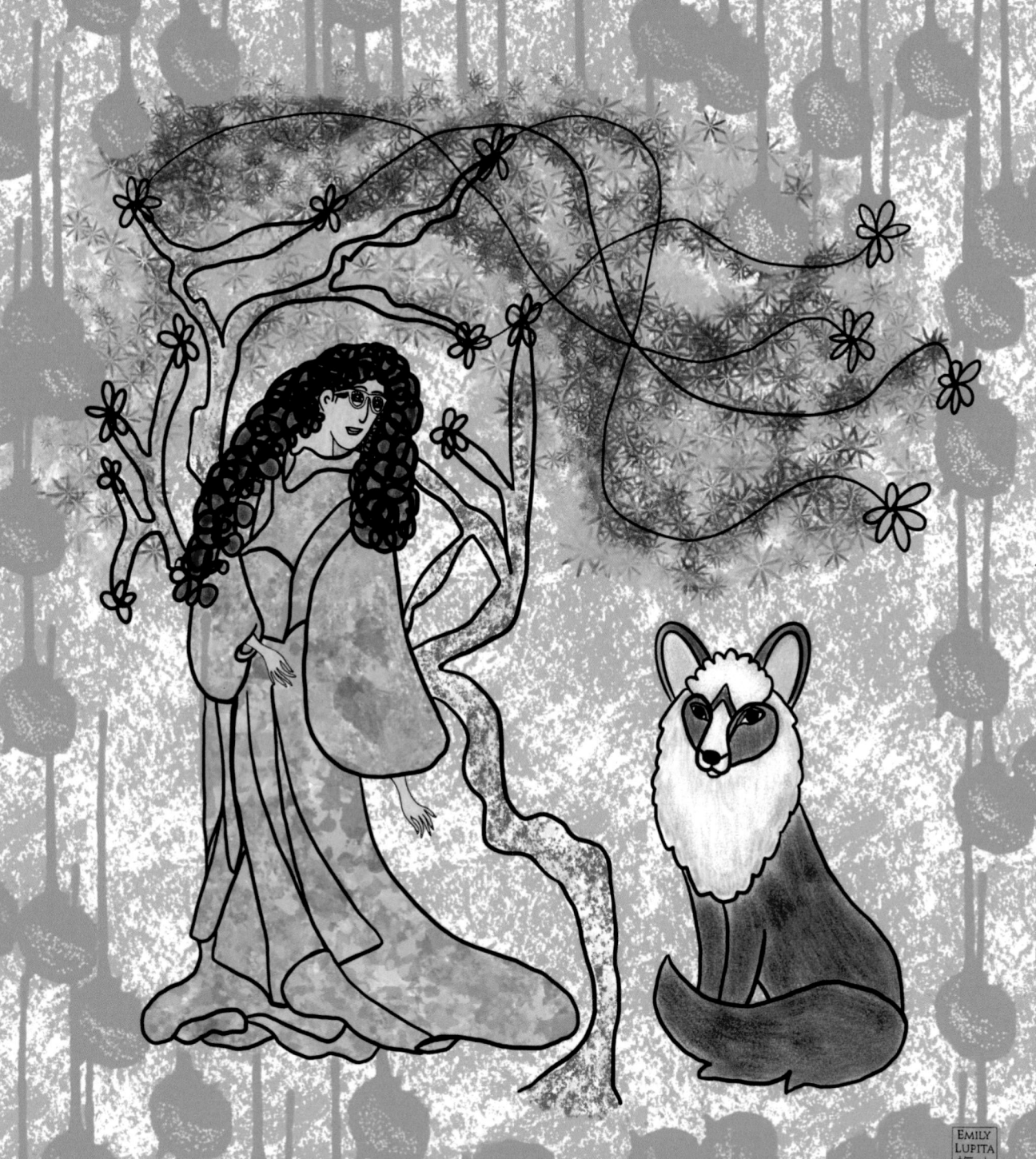

must we hasten old age with sorrow?
will it not come of its own tomorrow,
turning to fruit our most youthful flower,
releasing to seed our most sovereign power,
dissolving us again like water into mist
as eternity's gateway veil relentlessly lifts
to reveal heaven's fields sown with an earthly bliss
which waits to be harvested by a heart
that captures what these eyes will always miss?

please, awake my heart from beneath the hill
in the east, sleeping still. may deepening visions
come one by one each morning with the rising sun.
gather around me, starlord of infinite sight,
wash away the shadows of the night.
bathe me in your glowing light that i might see
the beauty of this day life has given me.

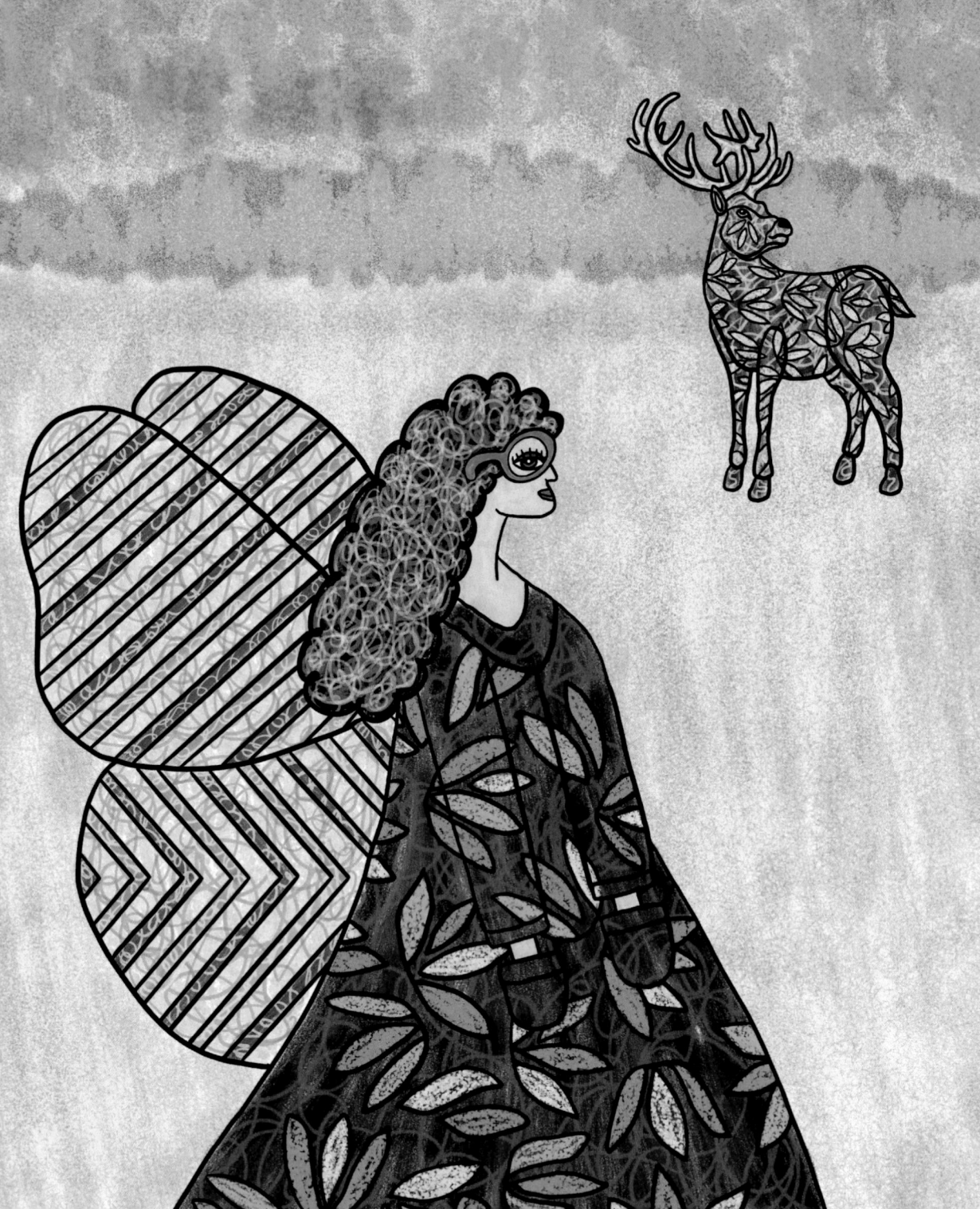

in the twilight just beginning

there is an instant never ending

when you go off and spinning

out across the milky way.

in the darkness always turning

towards the light of another morning

comes a moment without warning

when you're finally on your way.

while here

in this dim light of evening

i lie half asleep, rocking

in the cradle of another day.

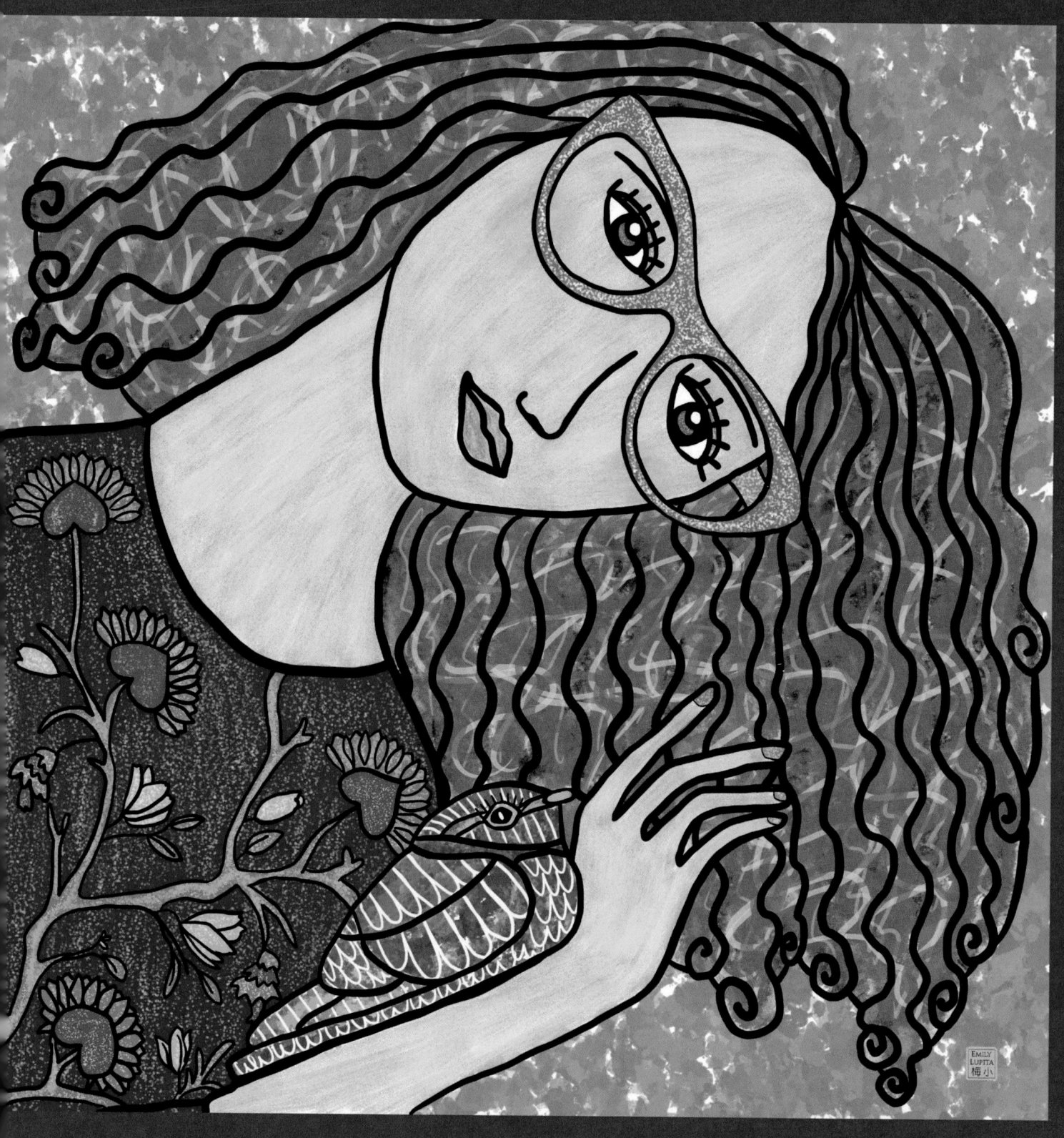

child of mine,
be the seed that always flowers, bear the fruits of time.
be this moment becoming hours, ripen on the vine.
be the sweet that never sours, throttle back your mind.
be the voice of ancient powers, carry on this rhyme.
be the children who are the children born of the promise
that was given in the gardens of mankind.

you are a ballet of shadows, a dance of lights,
an earthly landscape of endless insights.
a sense of being living in this time of becoming,
you are a deep well of feeling
feeding an oasis of homecoming.

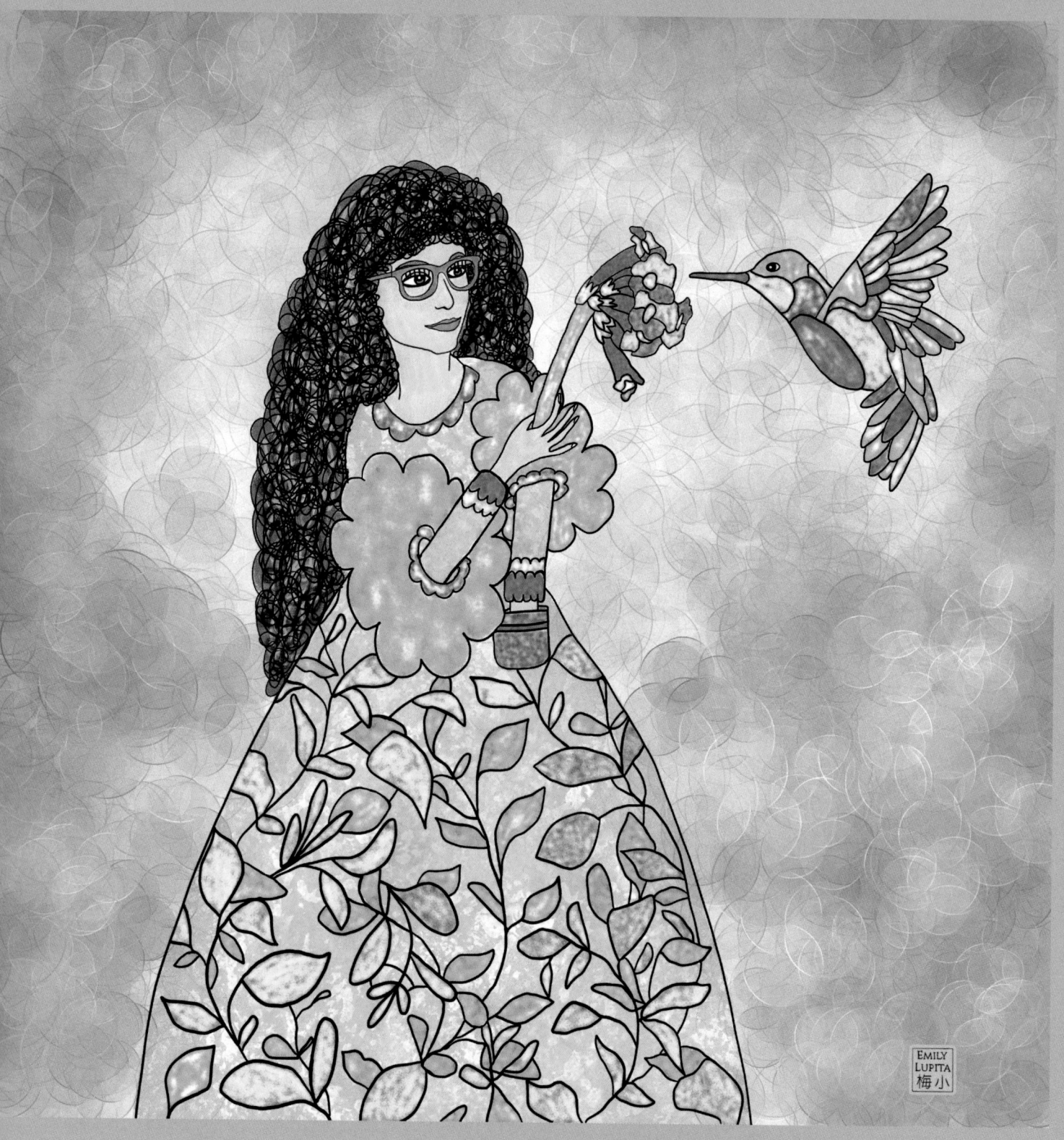

AND SO IT IS
THAT THE MOUNTAIN
COMES TO THE CLOUD
AND CLOUD TO THE MOUNTAIN,
FOR MOUNTAIN IS ANCESTOR TO THE CLOUD
AND CLOUD
CHILD OF THE MOUNTAIN'S BREATH
AND BREATH
FORCE AND WILL OF SPIRIT
AND SPIRIT
FIRE AND VAPOR OF LIFE.

TO FILL THE OCEANS,
EMPTY THE MIND
TO CLEANSE THE HEART,
CALIBRATE TIME
TO INSTRUCT THE EYE,
OPEN THE SOUL
TO CRADLE
THIS ONE SINGLE MOMENT
OF HOMECOMING,
JUST LET GO!

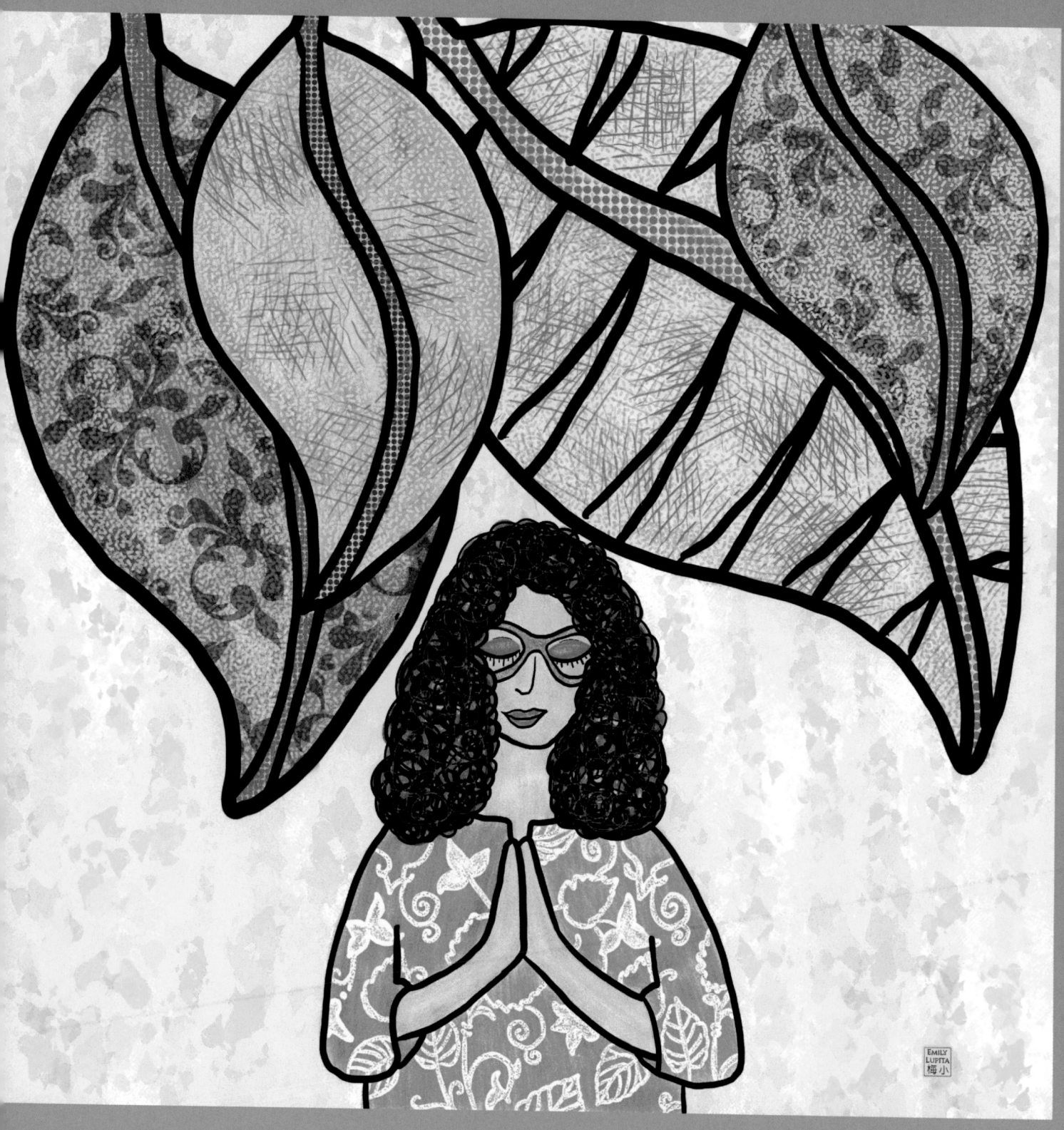

a painter of deserts labored for years,
laying grain upon grain and tear upon tear.
before the sun rose and after the moon fell,
she struggled not to struggle or drop into hell.
finally the artist had finished and she knew she'd done well,
for around her stretched the mountains of sand
all that had sprung from the tips of her hand.

all that she'd lost and all that she'd found
reached up to meet her and it pulled her down.
as the ground rushed to greet her with a sigh and a thud,
she tore her heart and she lost her blood
which flowed across the endless sand
to fill the portrait that the painter called man.

now the painter's been gone for many a year,
though her paints and her brushes both are still here.
so begin in the middle and end at the start,
trust in your luck and follow your heart.
when you do this with ease you've done your part
to give to yourself what can't be taught,
the talent to turn everyday life
into a work of art.

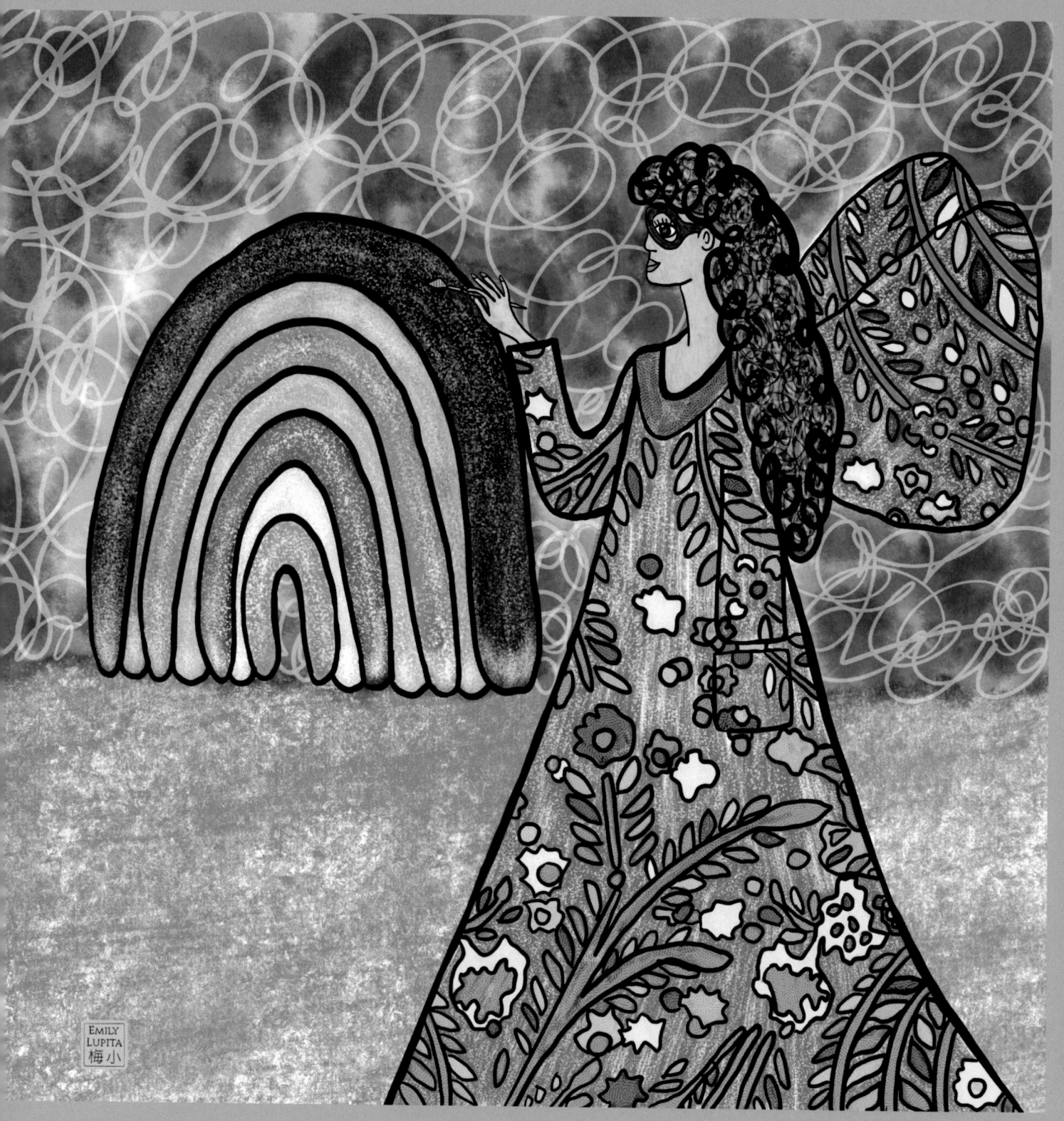

through this pool of living water

the ancestral stream empties into a river.

how well the current knows its course

with mountains and oceans both the source.

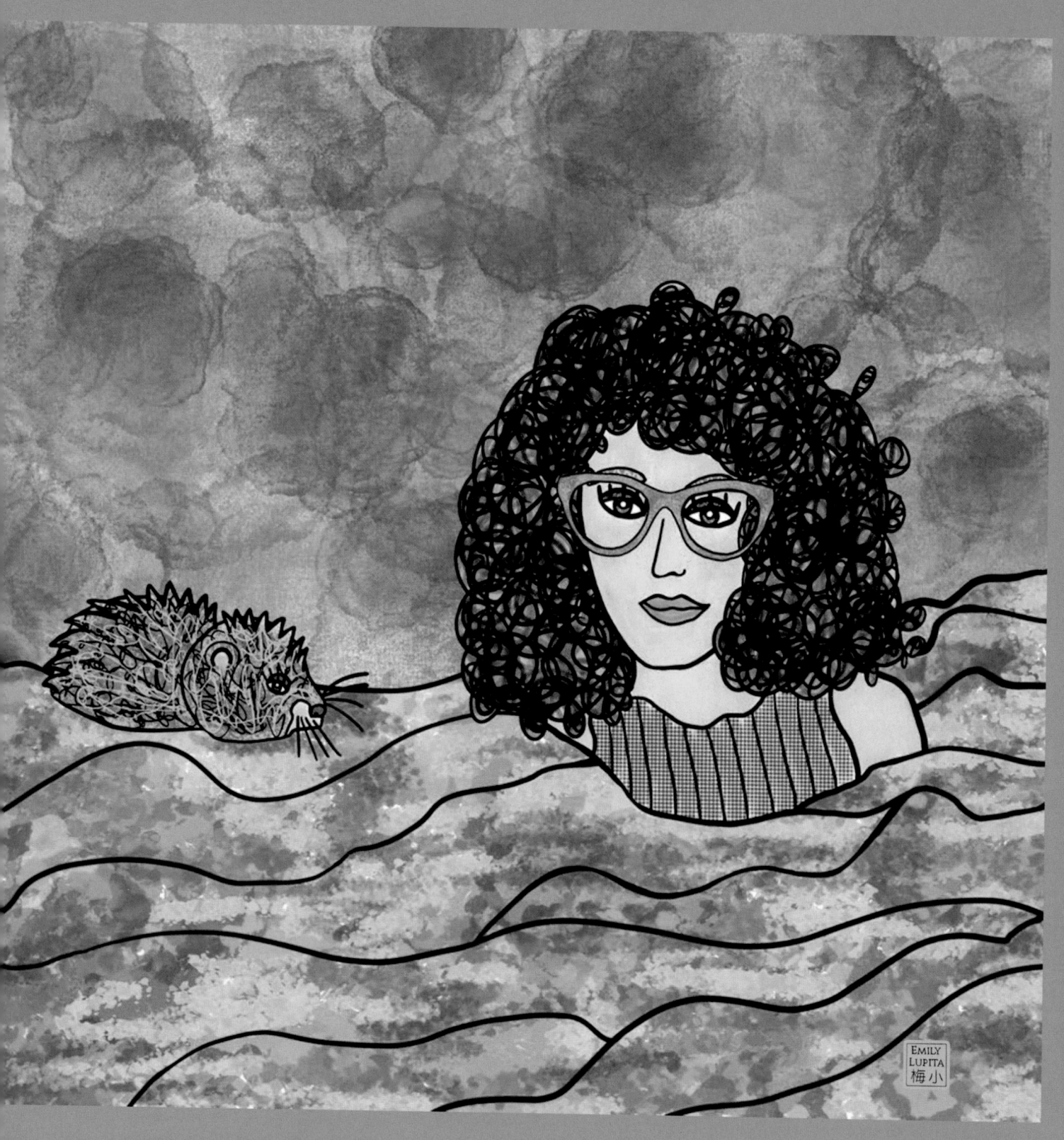

if human beings are battlefields,
then we must become overgrown with weeds
so all the bodies that have died but were never buried
can turn now into flowers who will someday
be dropping all their seeds

for if the sun is rising to chase away the dark,
then very soon the inner earth will again be warming
as these clouds of blindness begin again to part
and the gods of war who have been forever fighting
shall find a new conflict visited upon their hearts,
a conquest whose struggles end in silence,
alone, amid their own world's highest mountain tops.

by living in a human landscape with choices to be made,
the price of healing wounded innocence
is never quite completely paid unless the geometry
of the situation grows honestly from a matrix
born of instinctive faith so that the opportunity
to strike a reflex blow in the name of glory can,
without hesitation, be ultimately allowed to escape.

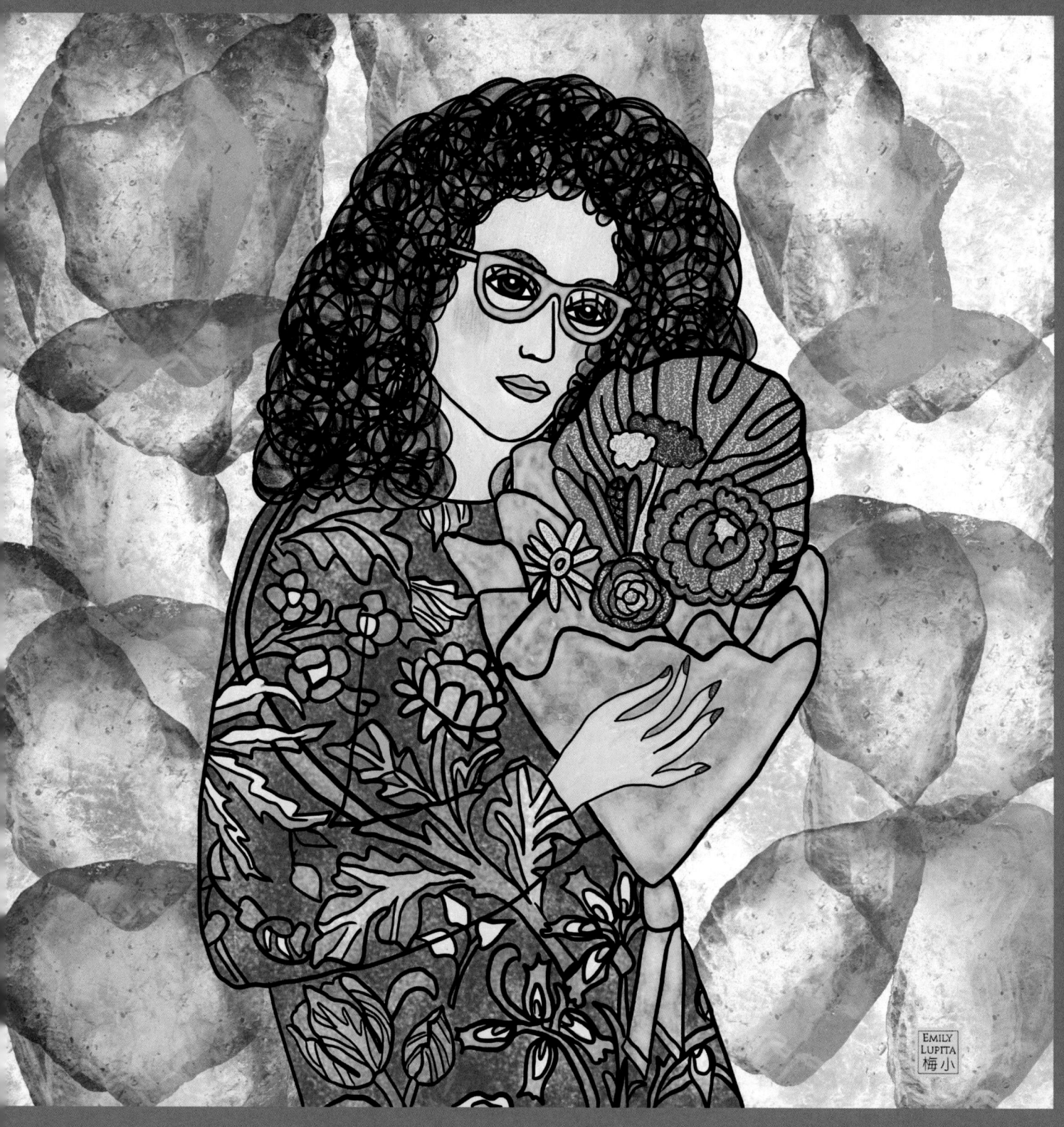

THROUGH THE SKY,
FIRST LIGHT IS STILL FALLING,
STRIKING THE EYE
WITH THE HOPE OF RECALLING
A PROMISE WHOSE WORKINGS
OPEN INTO THE CENTER
OF A BEING WHOSE FINEST THOUGHTS
ARE LIKE BIRDS IN THE SKY,
TURNING AND WHEELING,
ARISING IN UNISON
YET CONCEIVED APART,
A PATHWAY OF LIBERATION
LEADING DIRECTLY
THROUGH MIGRATION
INTO A FIRE
BEACON BURNING
IN THE HEART.

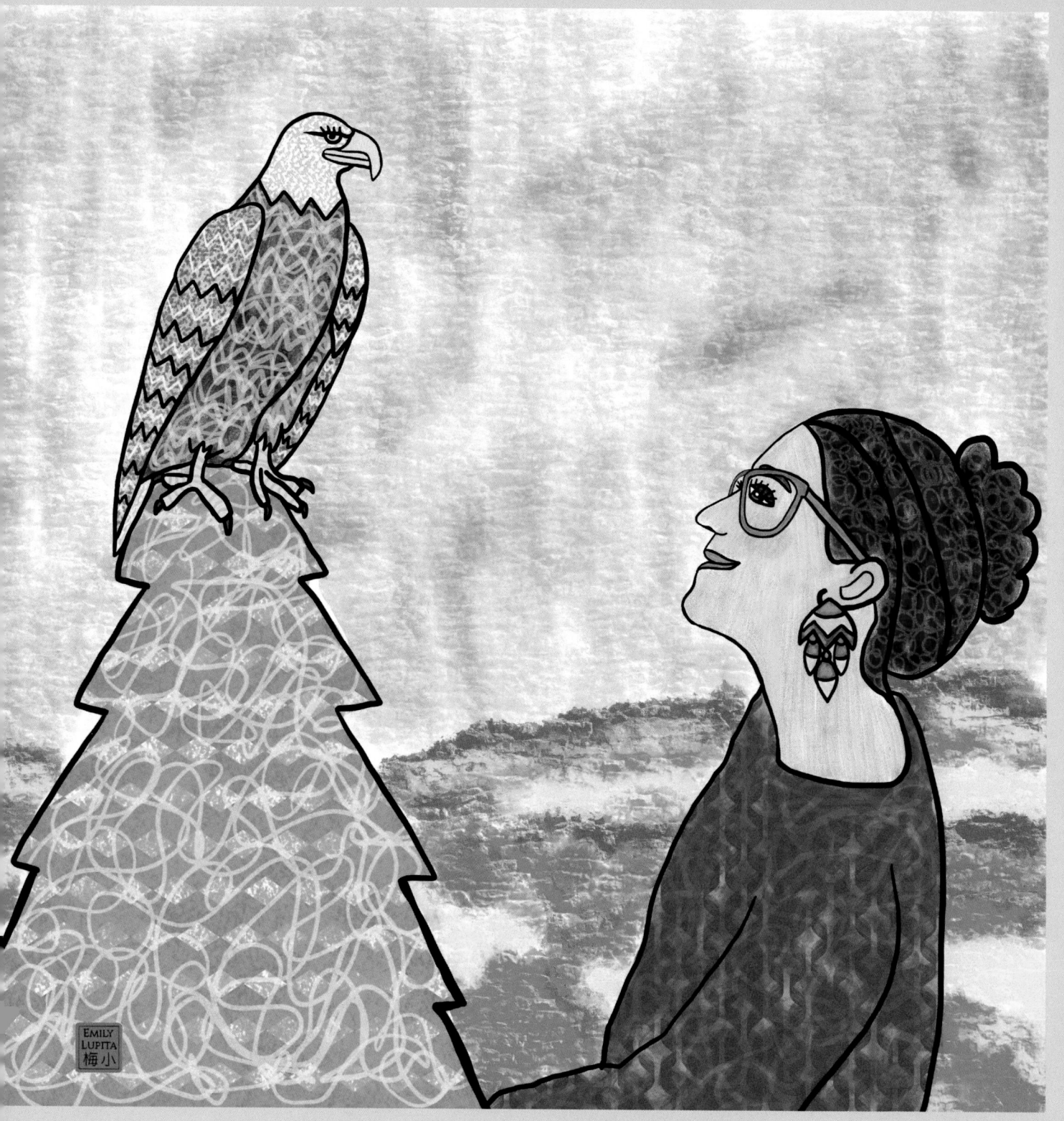

soft are the steps of the life force ascending
into the twilight vapors of a primordial sky
where broken by increments into constricted potential
long ago love in the ancient ways stopped flowing
and gave the rest of eternity the time to pass us by.

now we are like islands surrounded by oceans,
now we are like clouds climbing out of the sea.
now we are like starlight waiting for darkness
holding to a power in our hearts
that can set this world free.

look to the landscape for a view in the morning,
gaze into the eyes of this earth at your feet.
carry the moment like a child who is singing
alive with feeling so that tomorrow can be.

what more could we need to be complete?

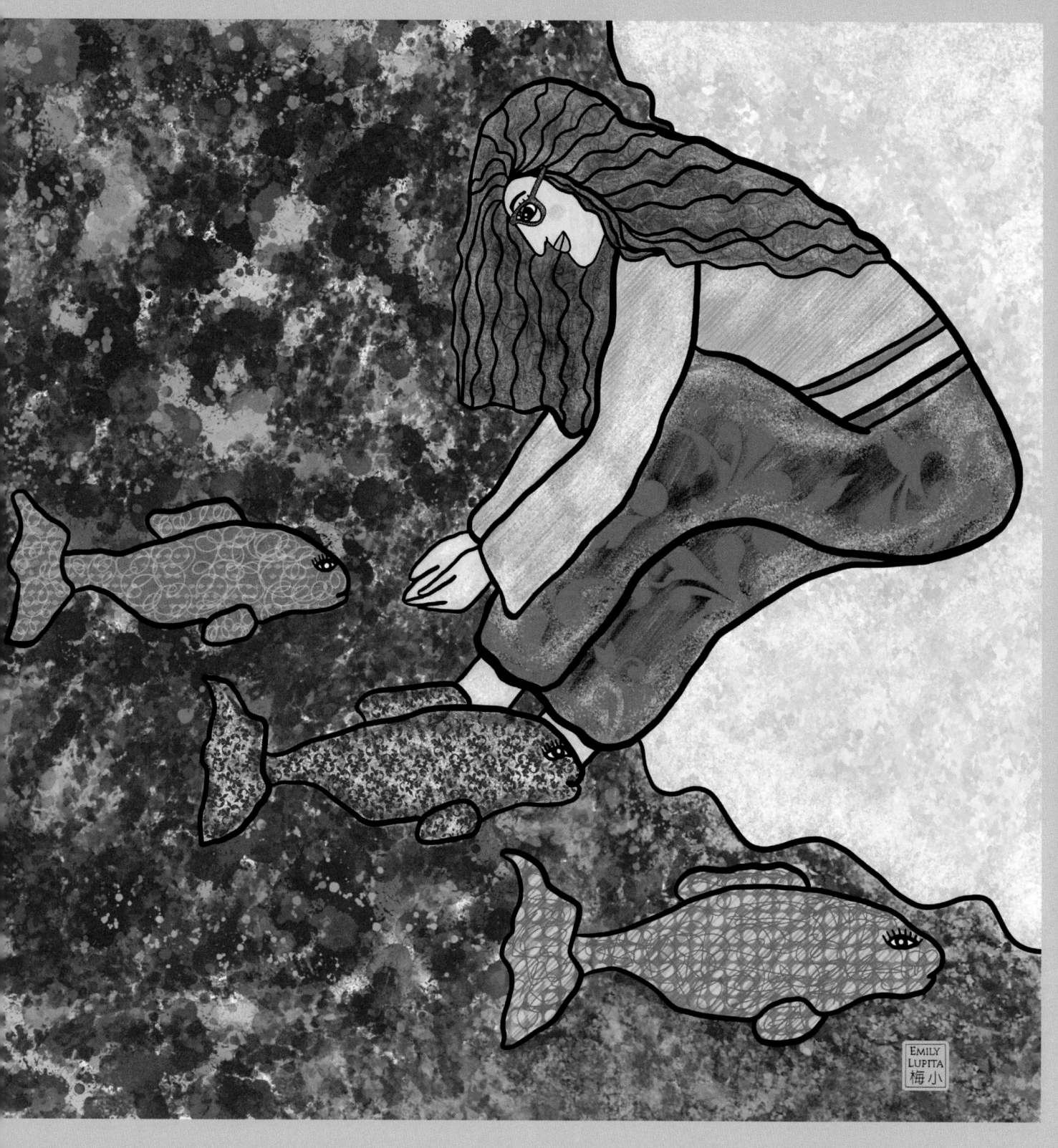

who lingers
half-sleeping in soft repose
or passing among temples of a distant time
or seeking unseen some future sign?

what is this fine breath of air,
this ageless gift from we know not where,
this sightless path scented
with honey vapor of silken tongue?

if it pleases the gods
may it be a truth
that love and destiny
are one.

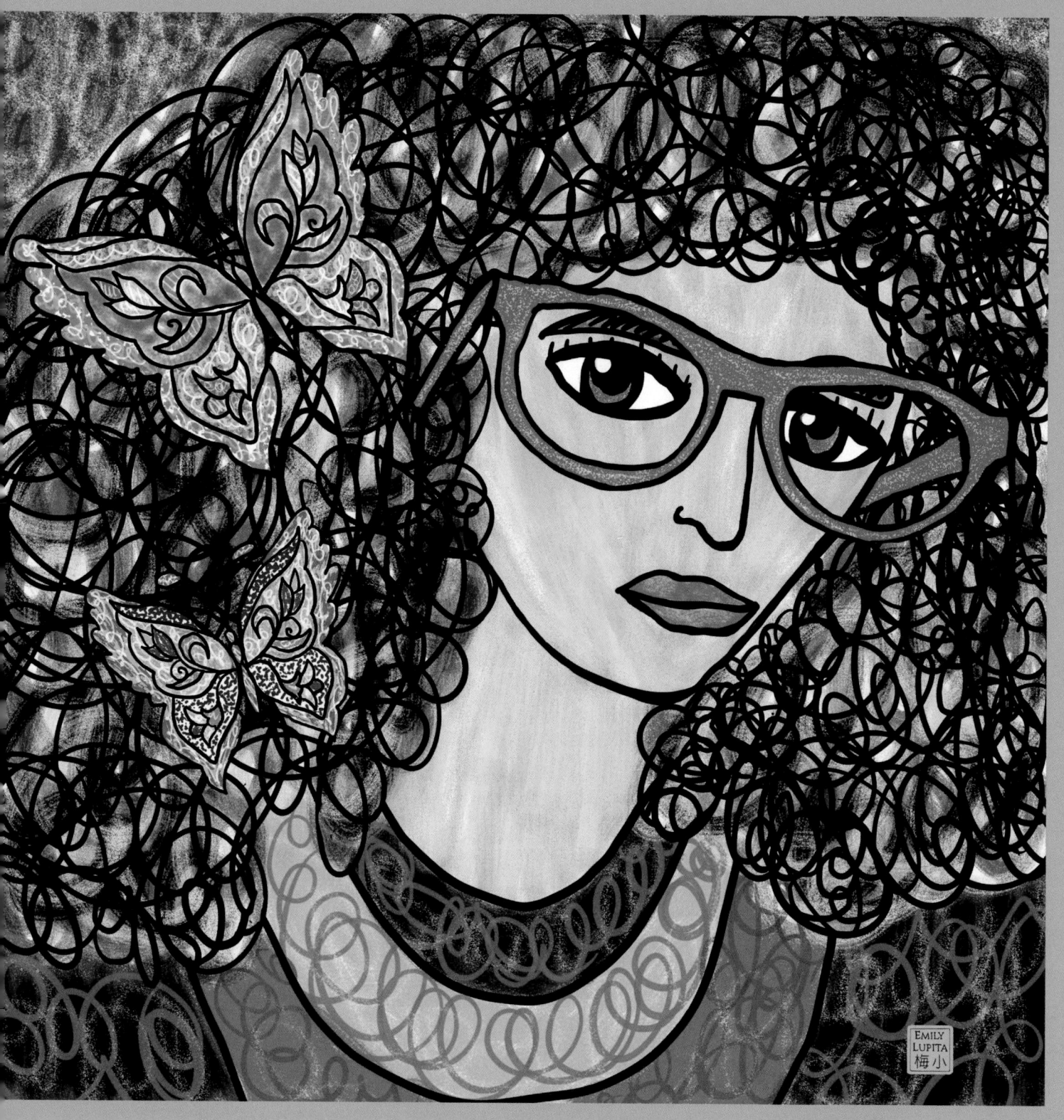

raven-tongued, back bent skyward,
sudden illness come morning.
a small sun rises beneath great hills,
clouds that would billow,
a star once brazen
now grown ashen to be swallowed
by swirling mountains above.

two crows, black flying black,
dip, decide to touch land,
walk, heads bent, to inspect
this distant window.

drifting. no anchor. no bounds.

small sounds stir,
blanketed in warmth
still chills run to perch
near the tips of a hand.

talk travels soft,
sinks deep into the heart
where beneath roofboard ribs
of this quiet house,
all day long with the wind
walls shake.

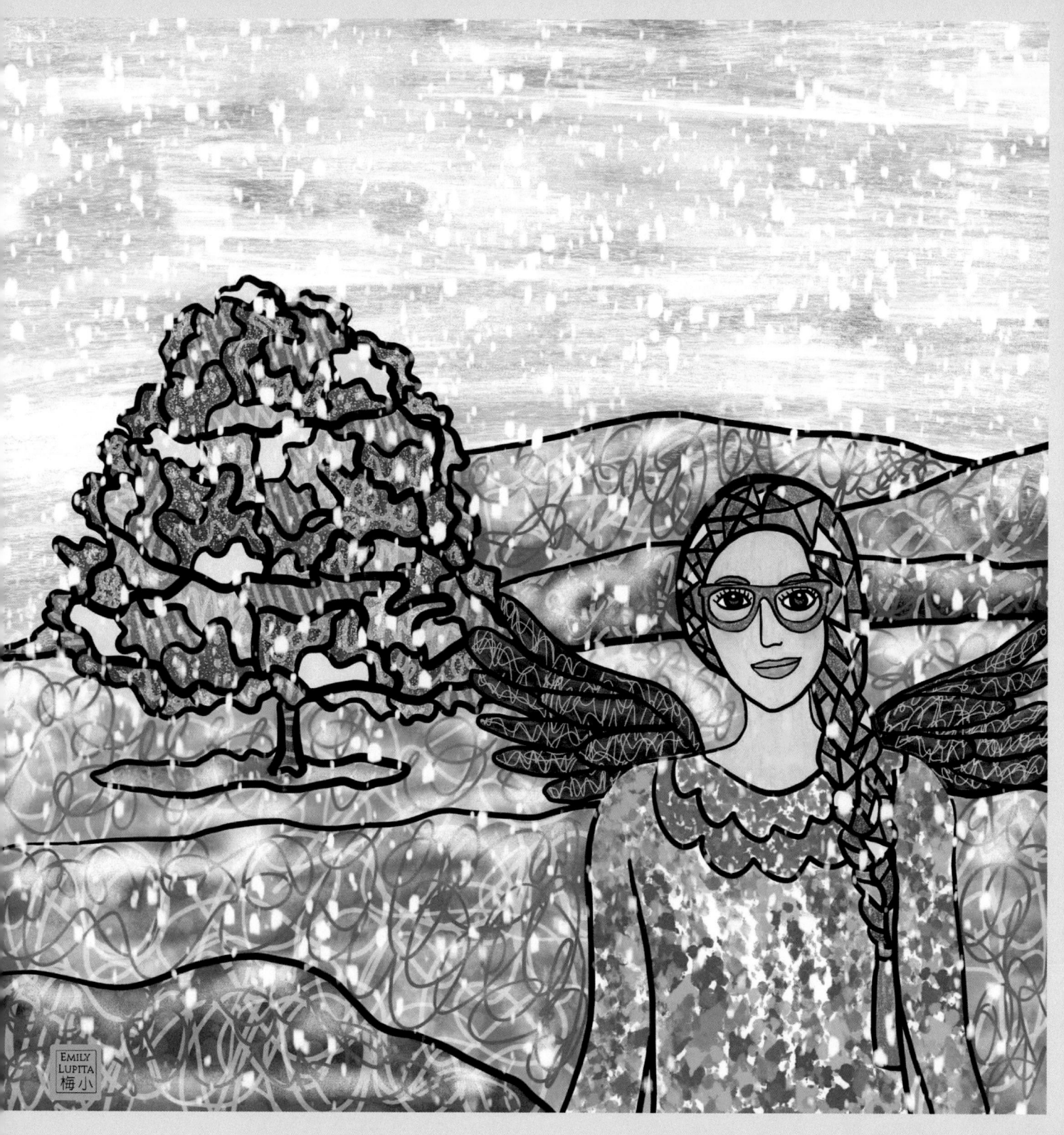

I AM A HUMAN RESERVOIR
FILLING WITH THE FLOOD WATERS
OF ANOTHER DIMENSION
WHERE I AM A WILLOW BONE FRAMEWORK
SUPPORTING THIS TENT OF SKIN.

I AM A CRYSTALLIZED VORTEX
OF UNEARTHLY WIND OPENING
DIRECTLY INTO THE SOURCE
OF THIS VISION WHICH BURNS WITHIN
WHERE I AM A CHILD
GENTLY CRADLED AGAINST THE LAND.

I AM DARK BLOOD RUNNING,
TOUCHING SAND
WHERE I AM A ROUGH
HOLLOWED WOODEN BOWL.

I AM A METAL HUED
TIGHT-LIPPED SOUL
WHERE I AM A WIND DRAWN
NAKED EYE.

I AM FIXED SIGHTLESS
ON AN EMPTY SKY.

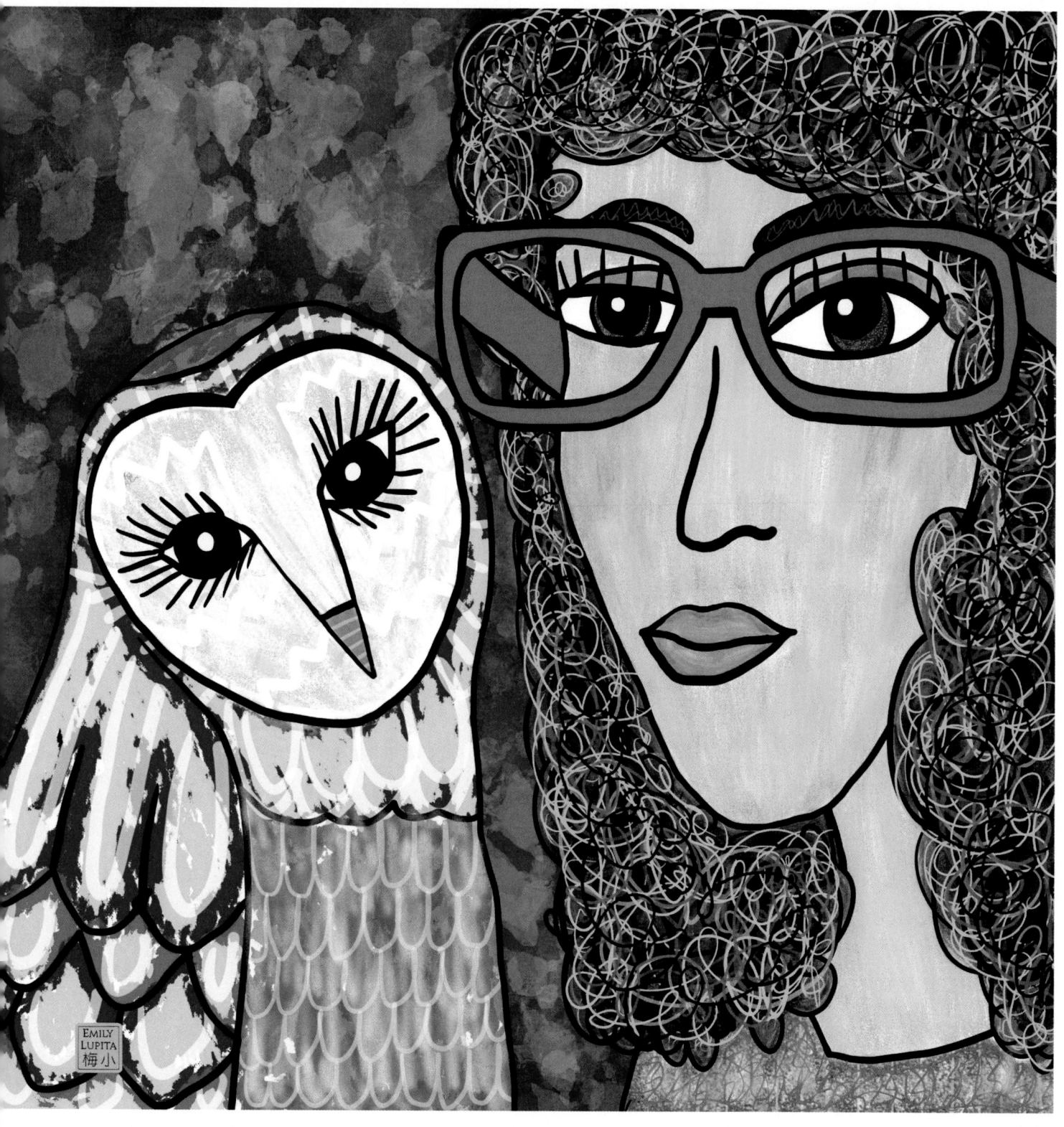

NESTED DEEP INSIDE THE HEART OF EACH OF US
THERE IS A FEELING WE MUST COME TO TRUST,
FOR IF WE ARE TO SPREAD OUR WINGS AND FLY
FIRST WE MUST GIVE UP ALL CONCEPT OF WHAT IT IS TO DIE.
LIKE CATERPILLARS GROWING FROM WITHIN A COCOON
WE MUST FACE EACH DAY WORKING TO BE AWAKENED SOON,
FOR NOT MUCH LONGER CAN THESE FEET SURVIVE
THIS EARTH BOUND PACE TO WHICH THEY'RE TIED
BEFORE THEY FEEL THE NEED TO CLIMB, TO TRANSFORM,
THEN TO RIDE BENEATH SILKEN WINGS THAT GLIDE
ON EFFERVESCENT CURRENTS AND VISIONARY TIDES.

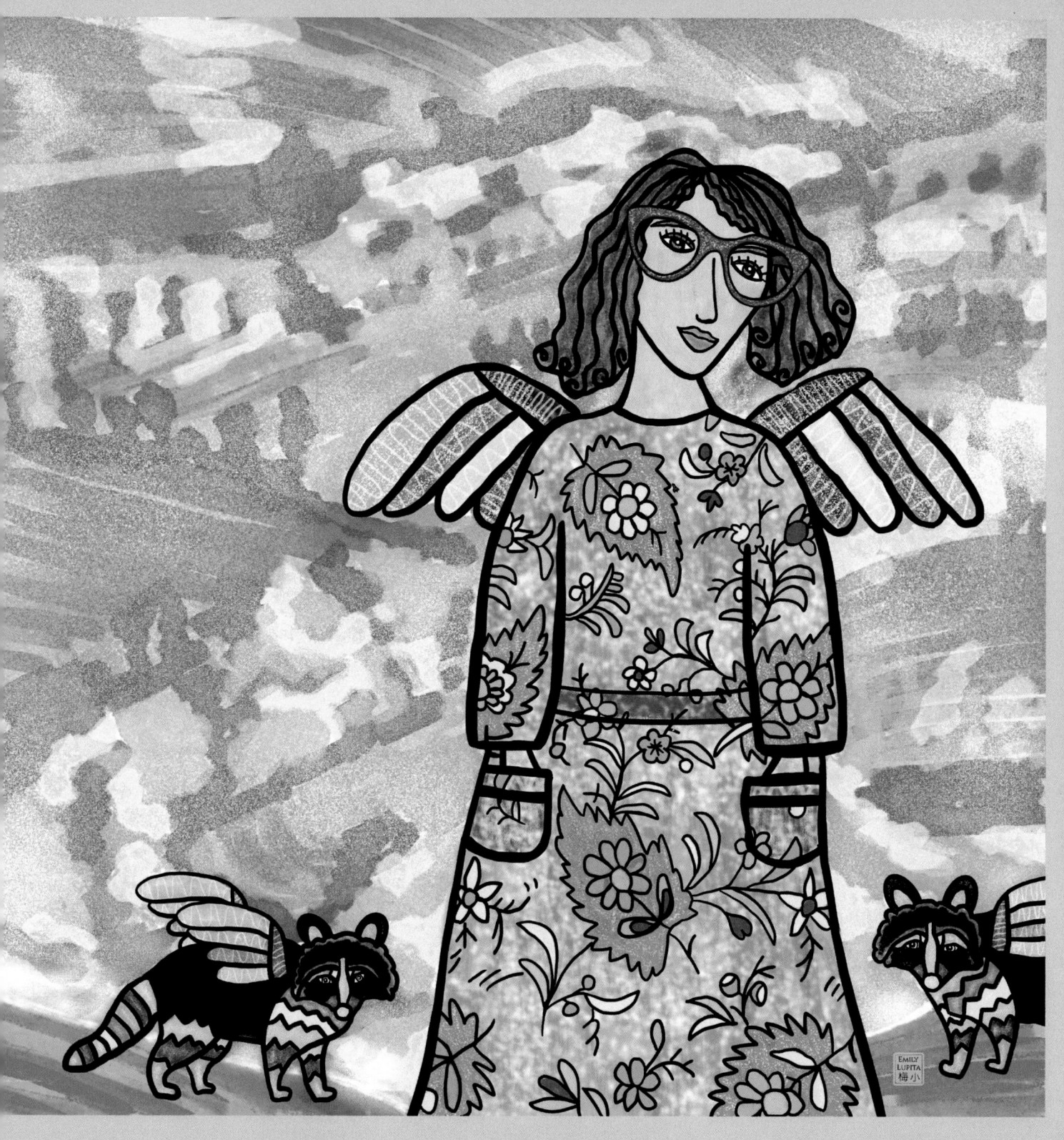

WHO HAS GATHERED THE SEEDS
THAT HAVE BEEN EONS IN THE SOWING?

WHO HAS CAPTURED THE THOUGHTS
WHICH KEEP THE KNOWER FROM THE KNOWING?

WHO HAS HARVESTED THE SILENCE
FROM WHICH THESE WORDS KEEP ON FLOWING
THAT THROUGH HEARING,
UNDERSTANDING MAY LEAD INTO A FEELING
WHICH IS FOREVER SHOWING
INFALLIBLE INSTINCT TO BE THE SOURCE
OF ALL THINGS ALIVE AND GROWING?

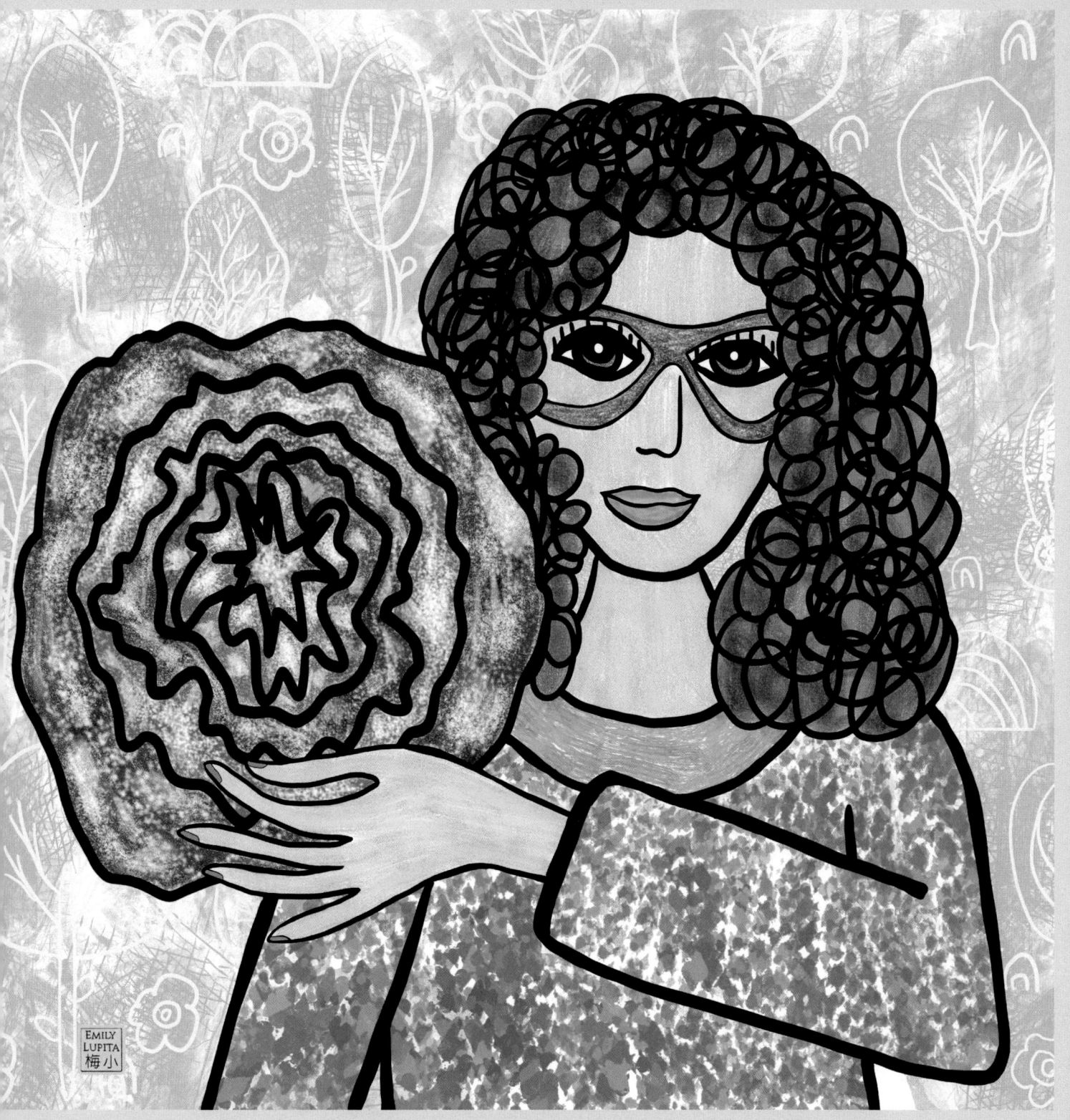

oath of dust just returning
cast no shadow to the ground,
beyond limits set by understanding
a still voice approaches sound,
while across these hills a fierce
allegiance hung with ribbons cold
brings for us a map to heaven
on which starry dreams unfold.

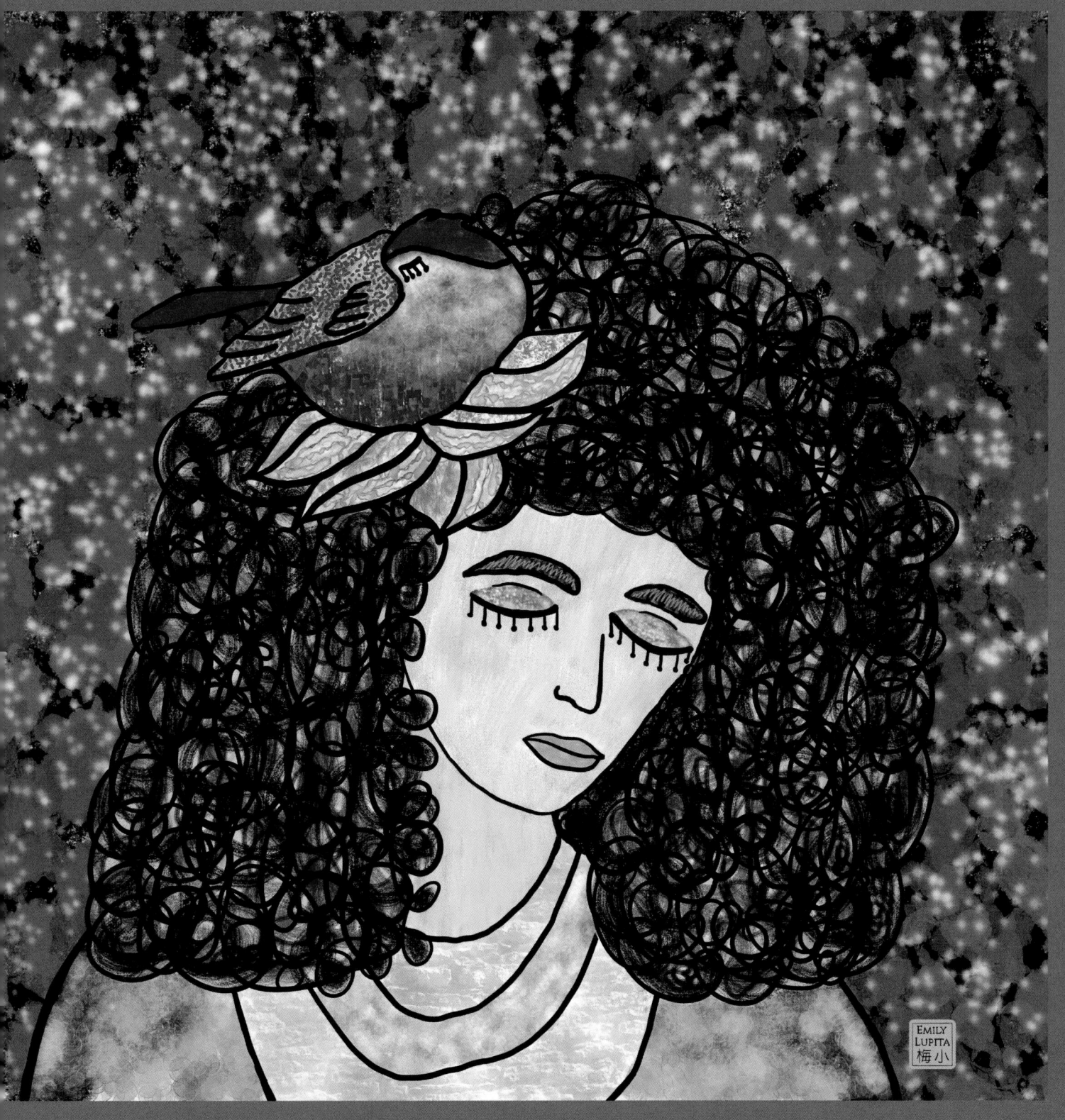

stay with me
earth's gravity said
to the moon
as the sun was passing by.

i'll never leave
promised night time's shadow
to the morning
as a bright new dawn
filled the sky.

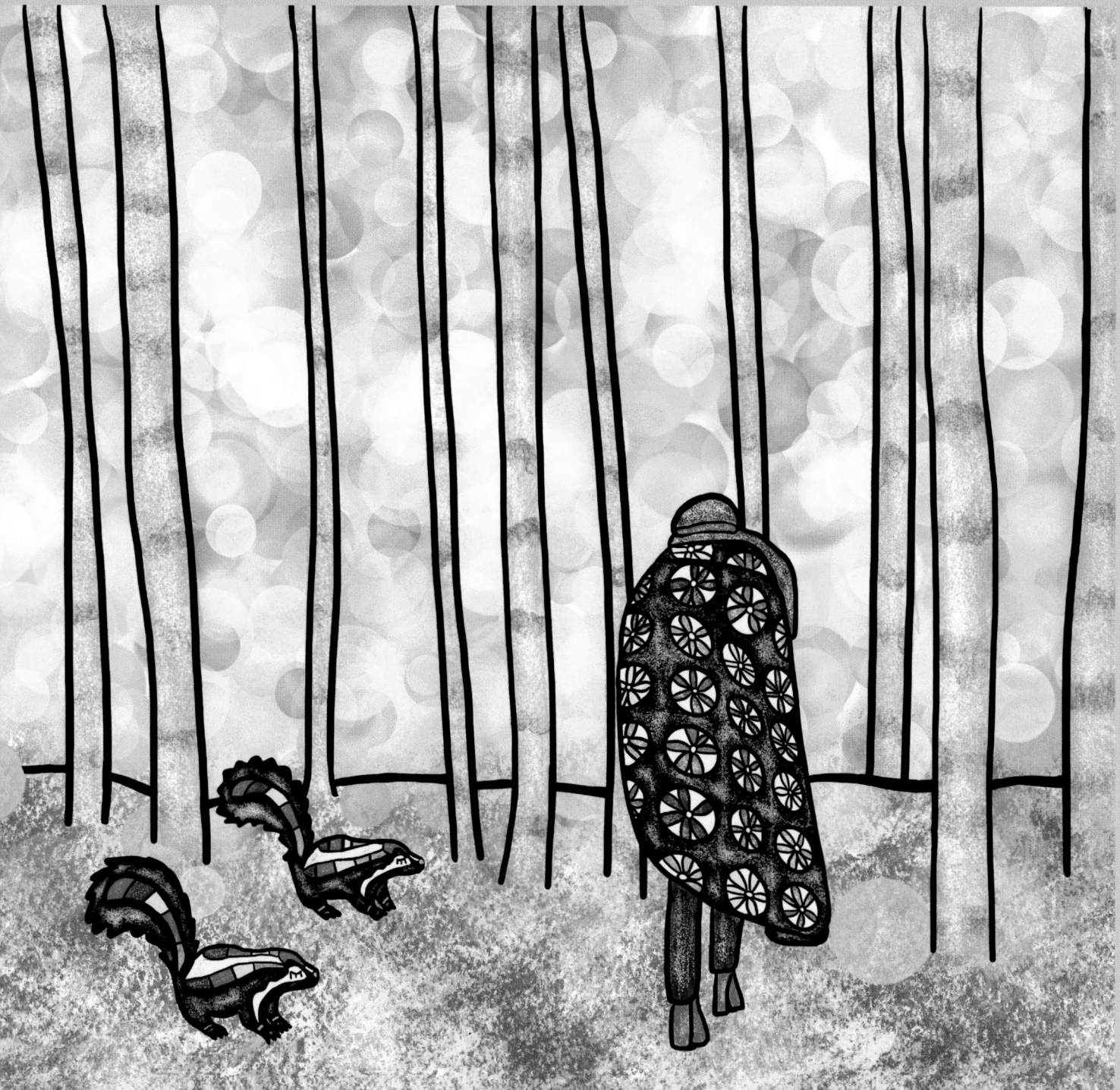

MEET THE ARTISTS

EMILY LUPITA

EMILY LUPITA IS A WATERCOLOR ARTIST
AND DIGITAL ILLUSTRATOR.
EMILY LUPITA'S ARTWORK HAS BEEN
INFLUENCED BY HER CHILDHOOD IN RURAL
IOWA, HER MEXICAN AMERICAN + WELSH
HERITAGE, AND HER EXPERIENCES LIVING IN
DIFFERENT CULTURES AROUND THE WORLD,
THIS IS HER FOURTH BOOK.

WWW.EMILYLUPITA.COM

JOSEPH S. PLUM

JOSEPH S. PLUM IS A POET IN THE BARDIC
TRADITION AND AN ACRYLIC ARTIST. HE LIVES
OFF THE GRID IN RURAL IOWA. JOSEPH'S POETRY
HAS BEEN INFLUENCED BY A LIFETIME IN THE
TIMBER, HIS EXTENSIVE TRAVELS TO NATURAL
PARKS AND PLACES, AND HIS WELSH HERITAGE.
HE IS EMILY LUPITA'S FATHER.
THIS IS HIS NINTH BOOK.

WWW.JOEPLUM.COM

Made in the USA
Middletown, DE
22 June 2022